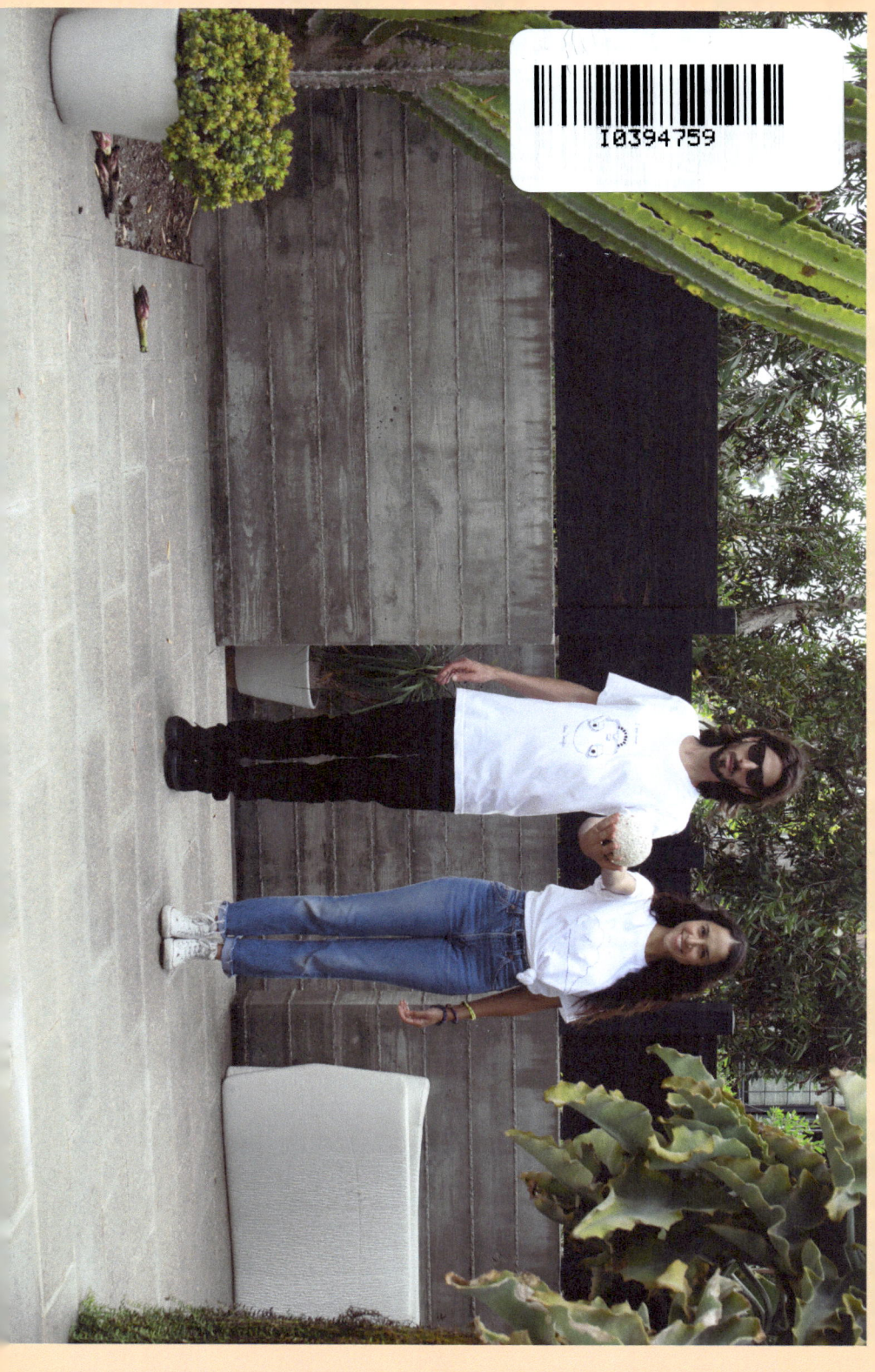

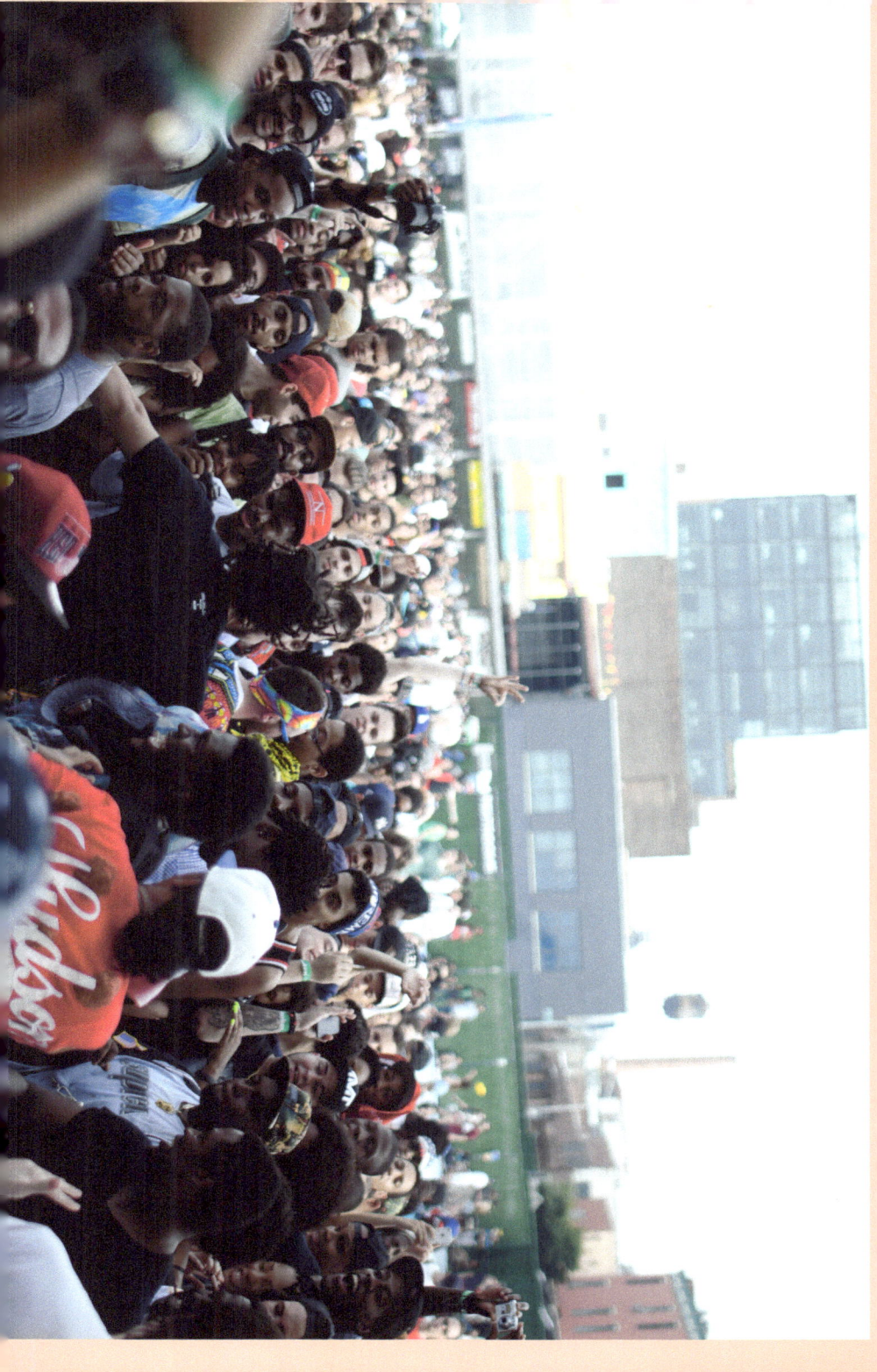

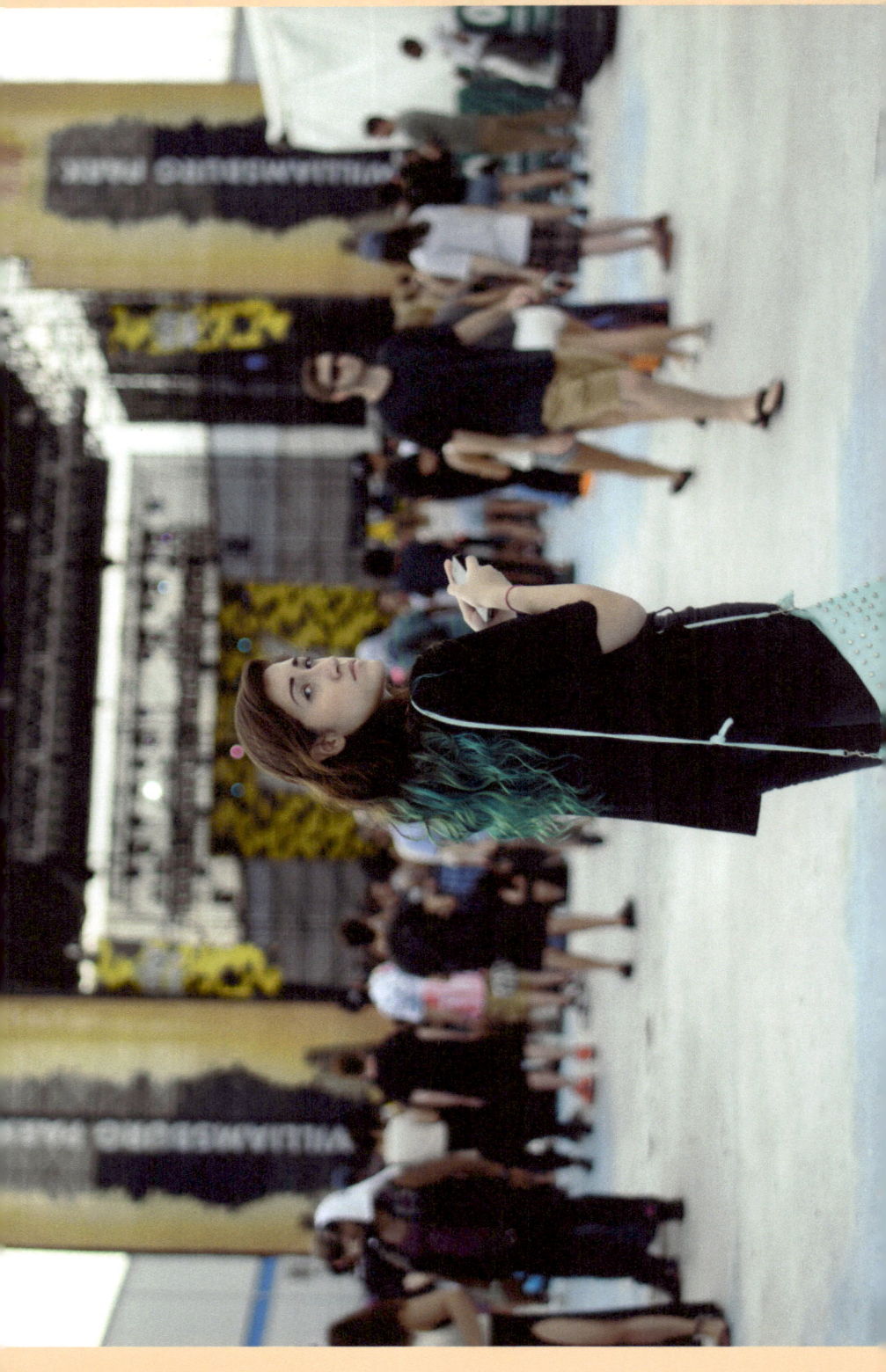

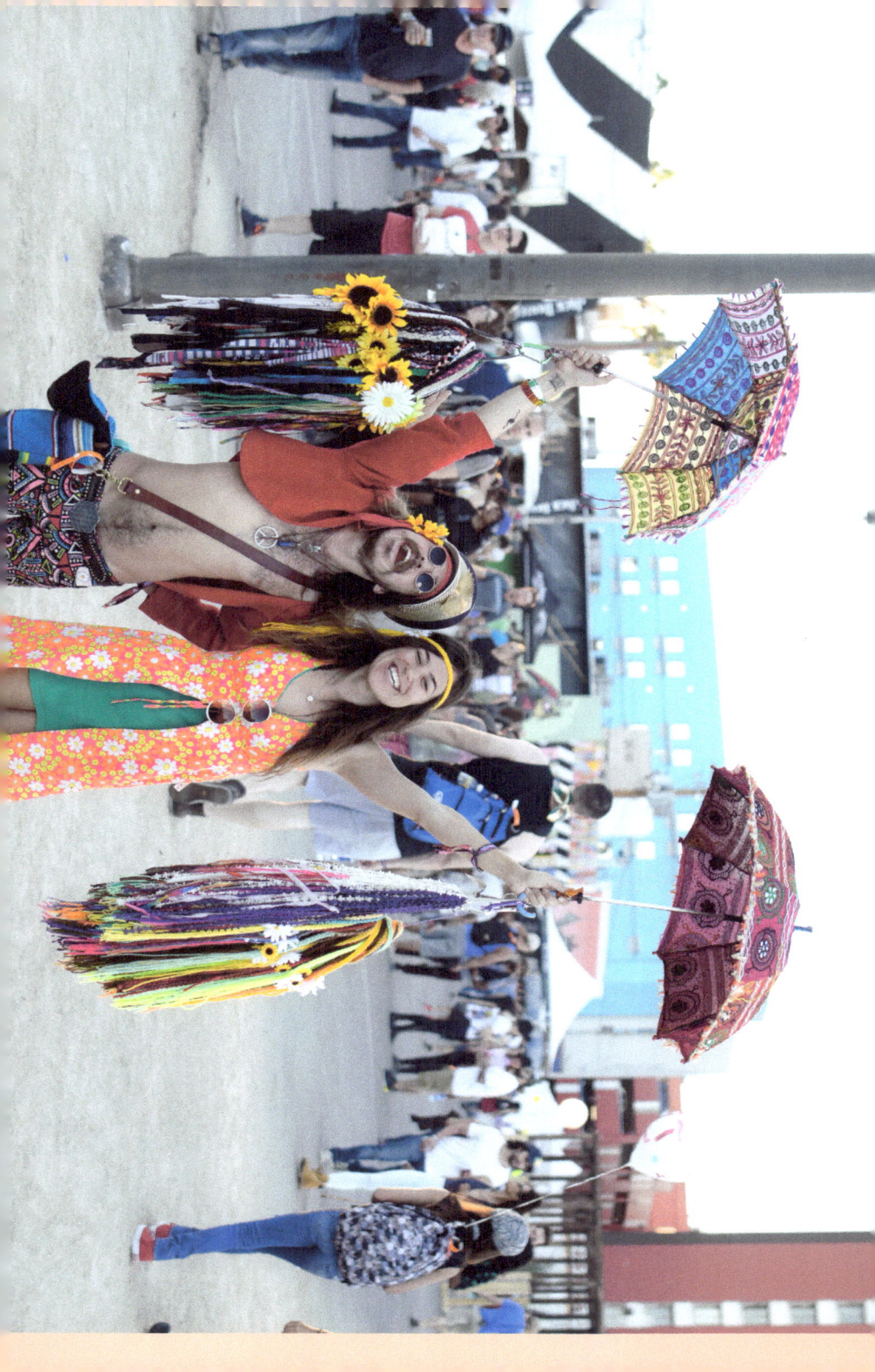

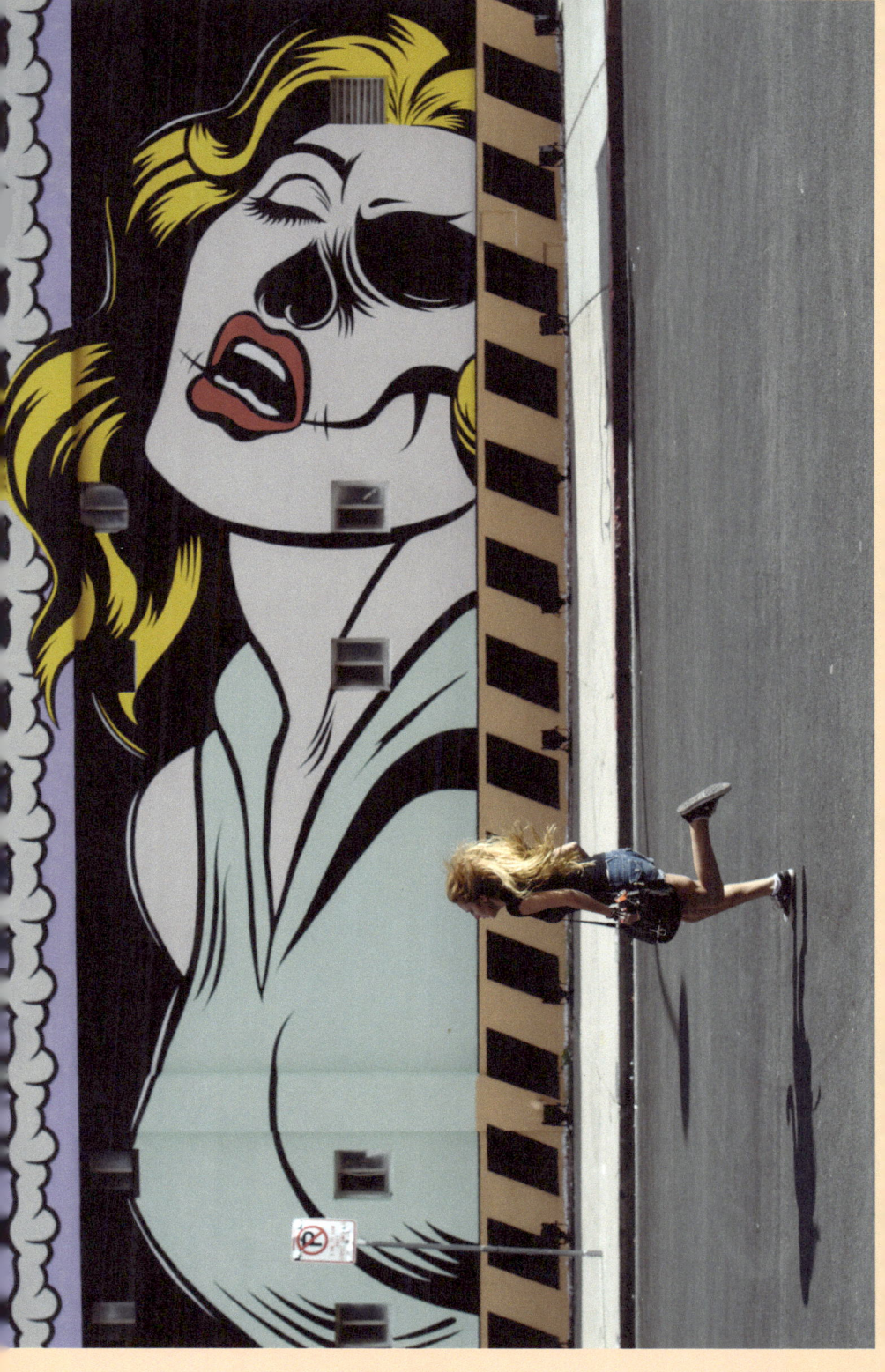

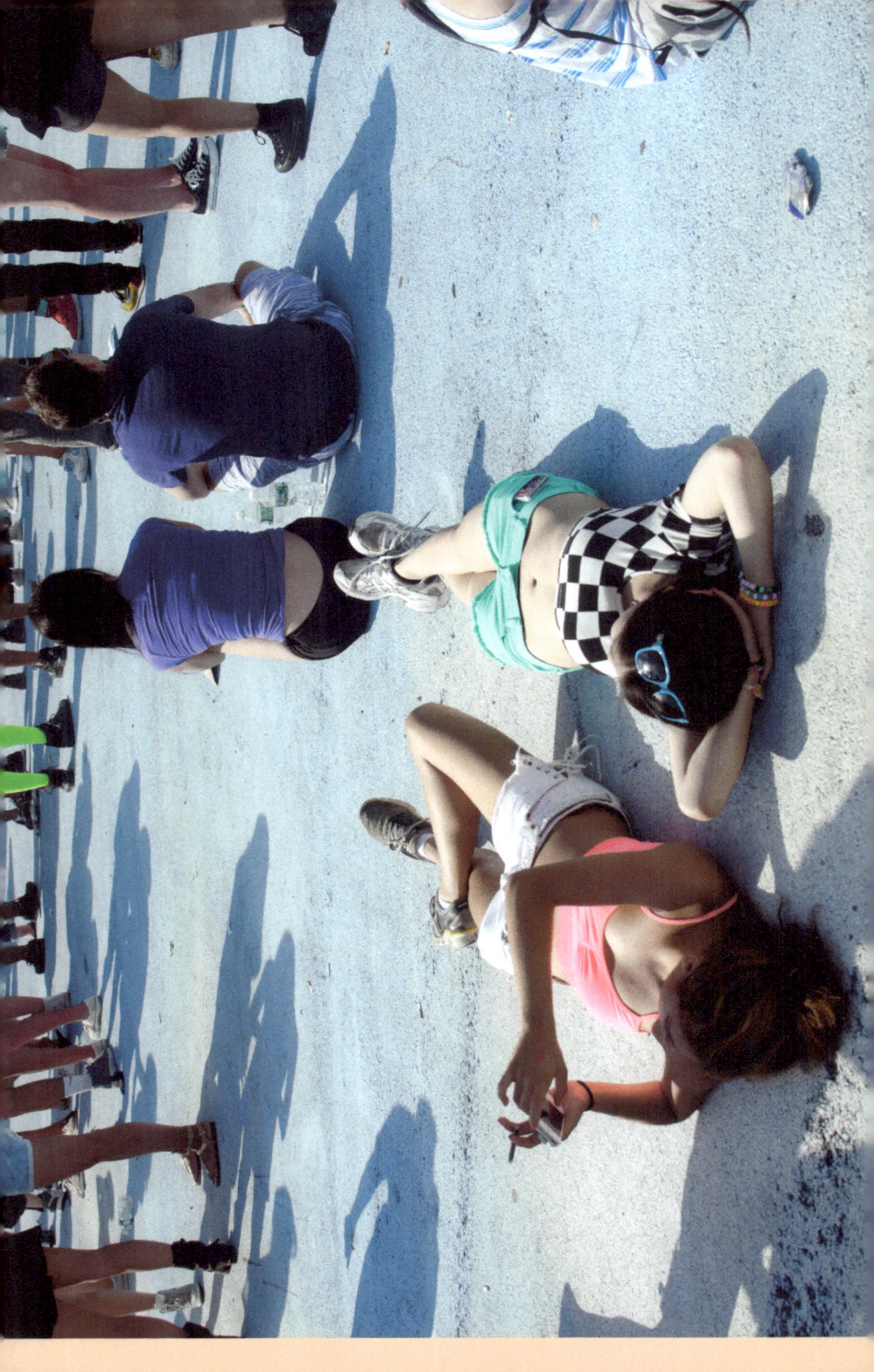

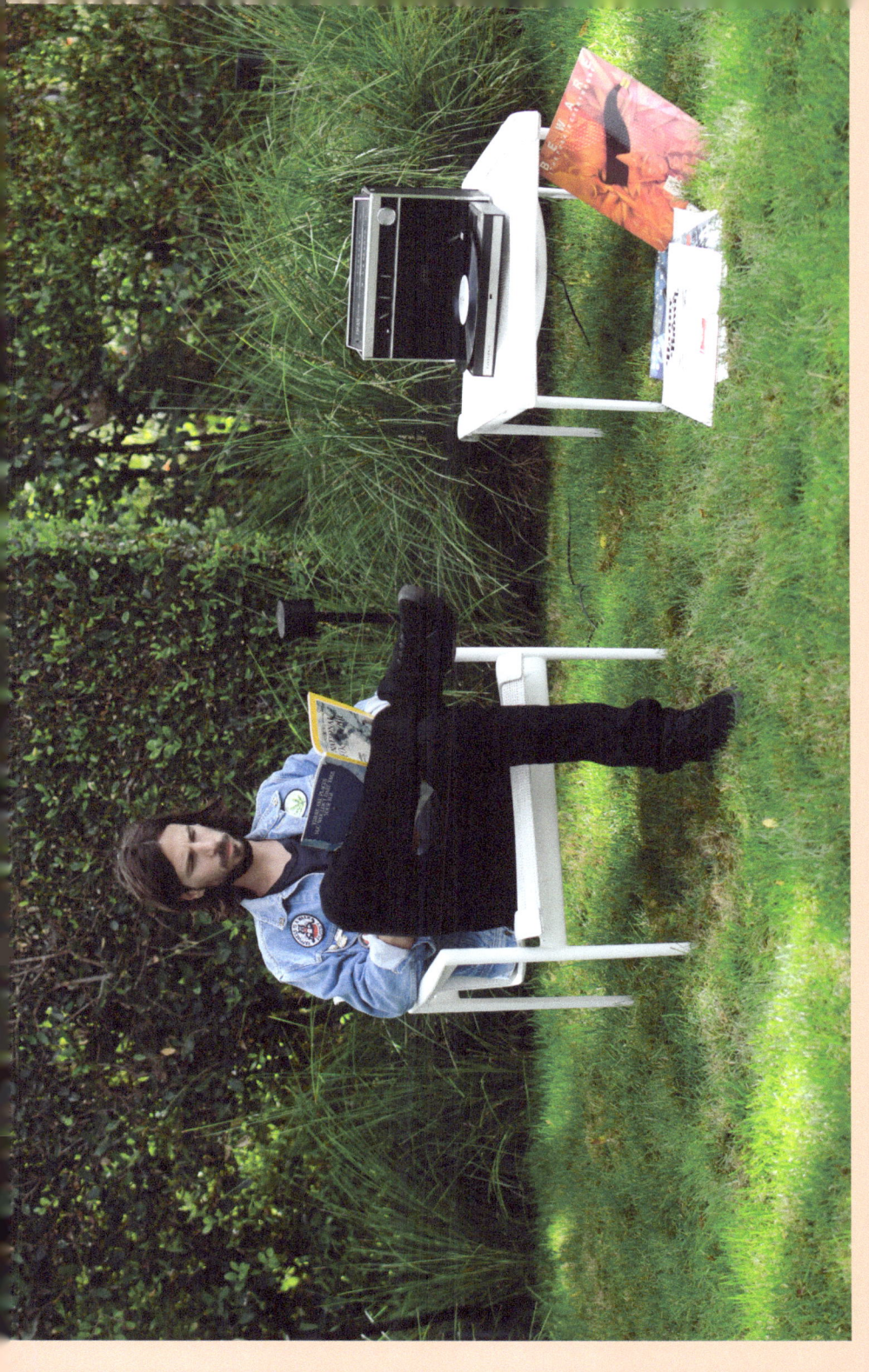

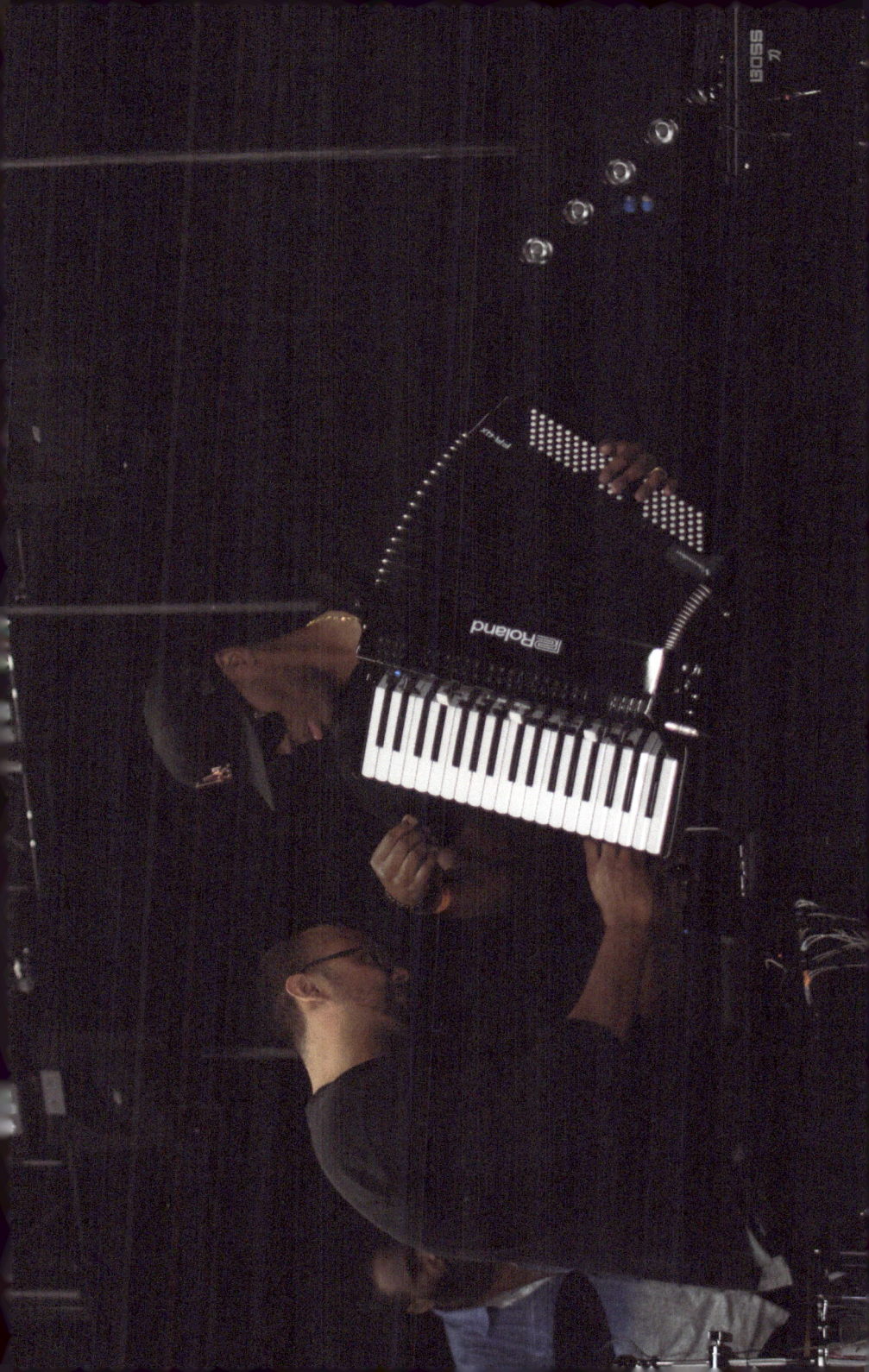

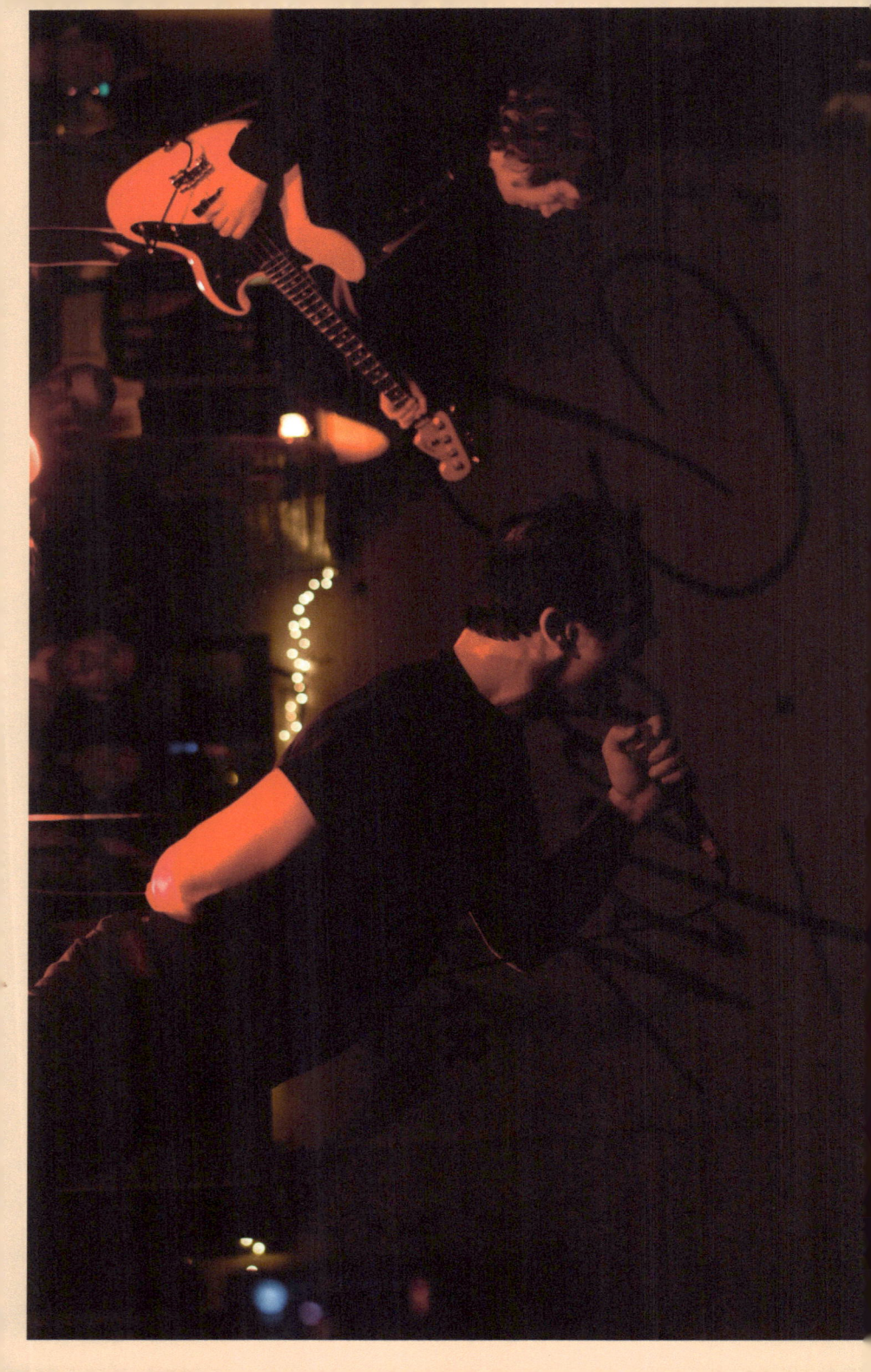

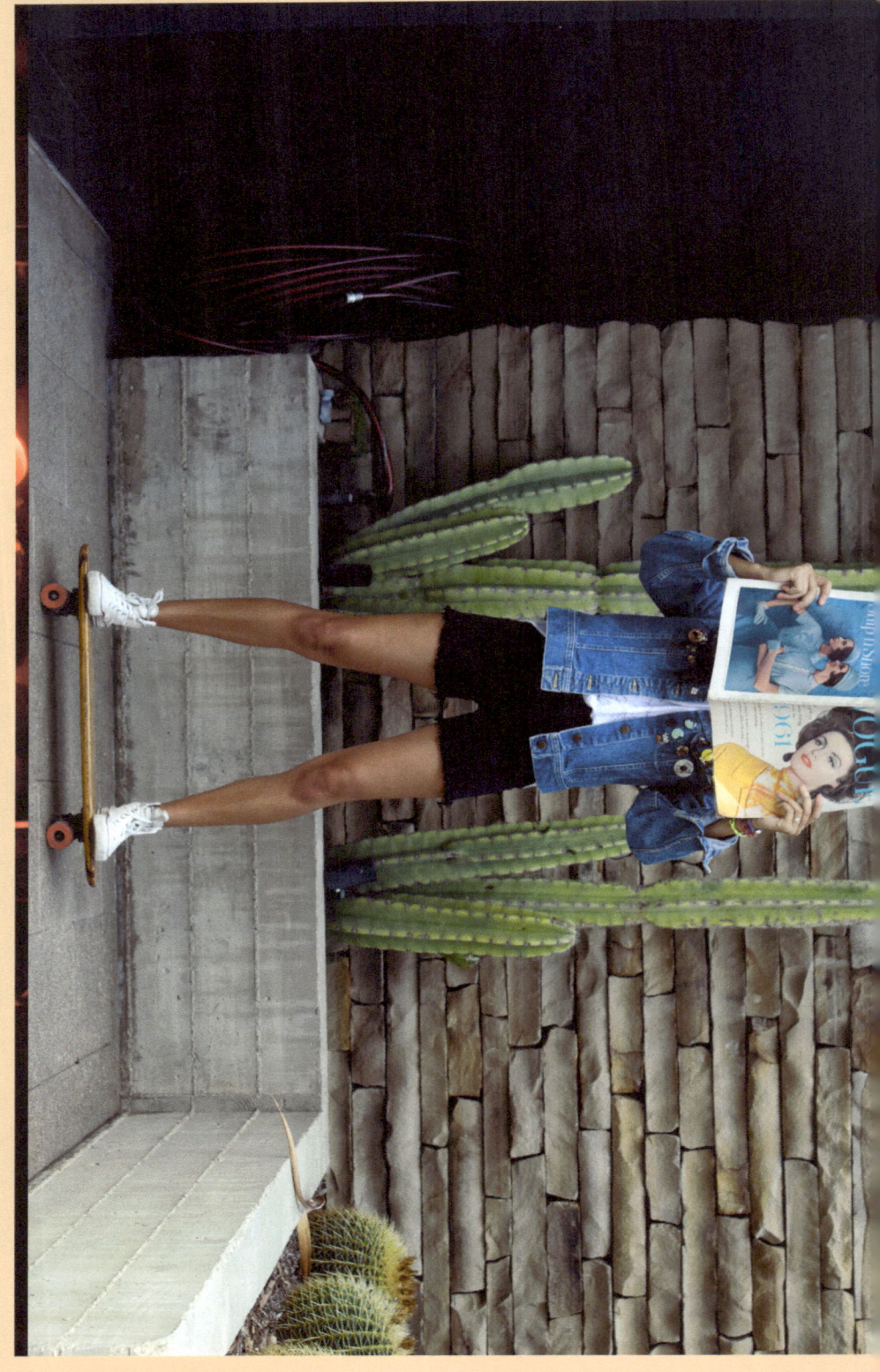

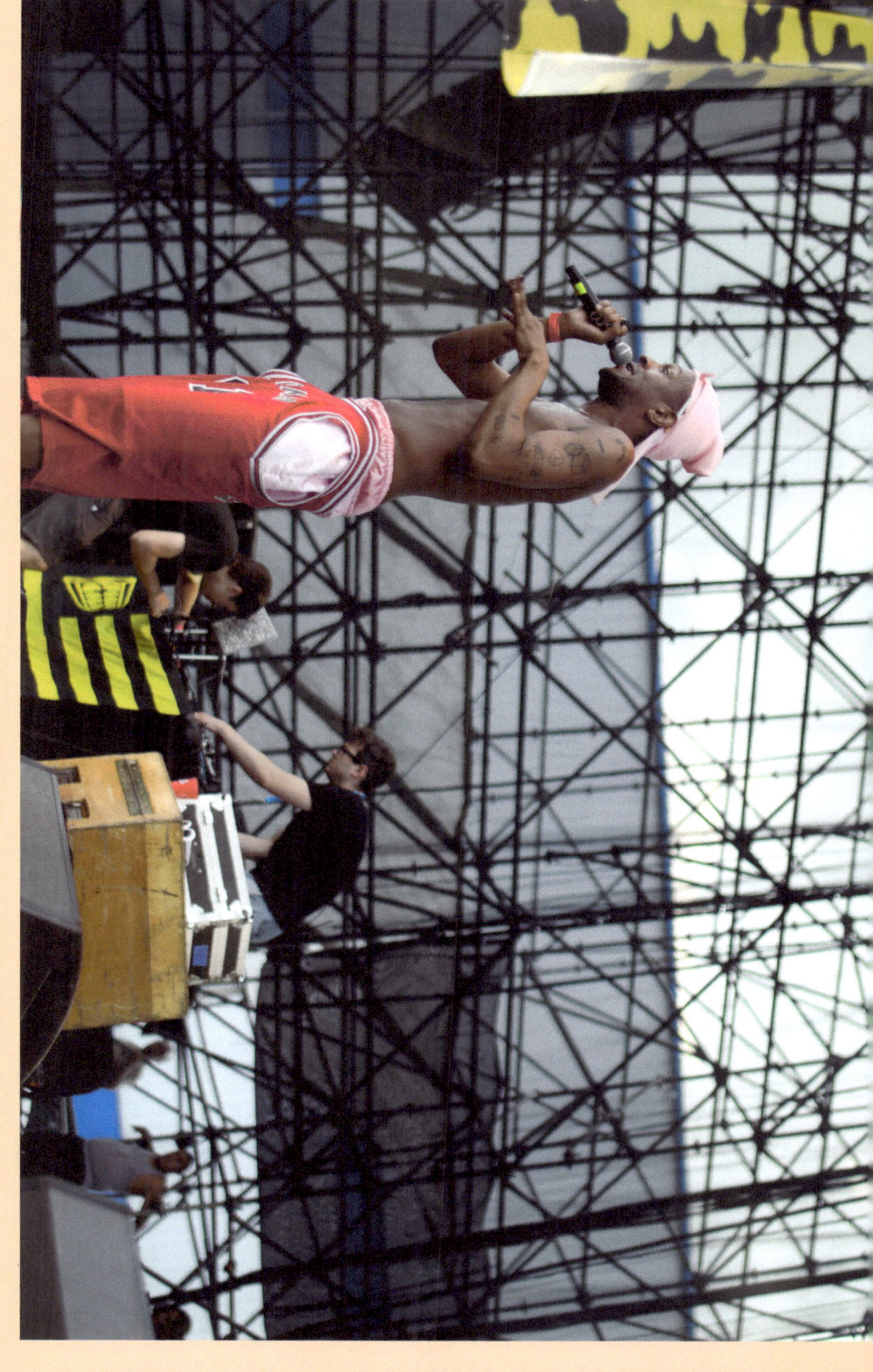

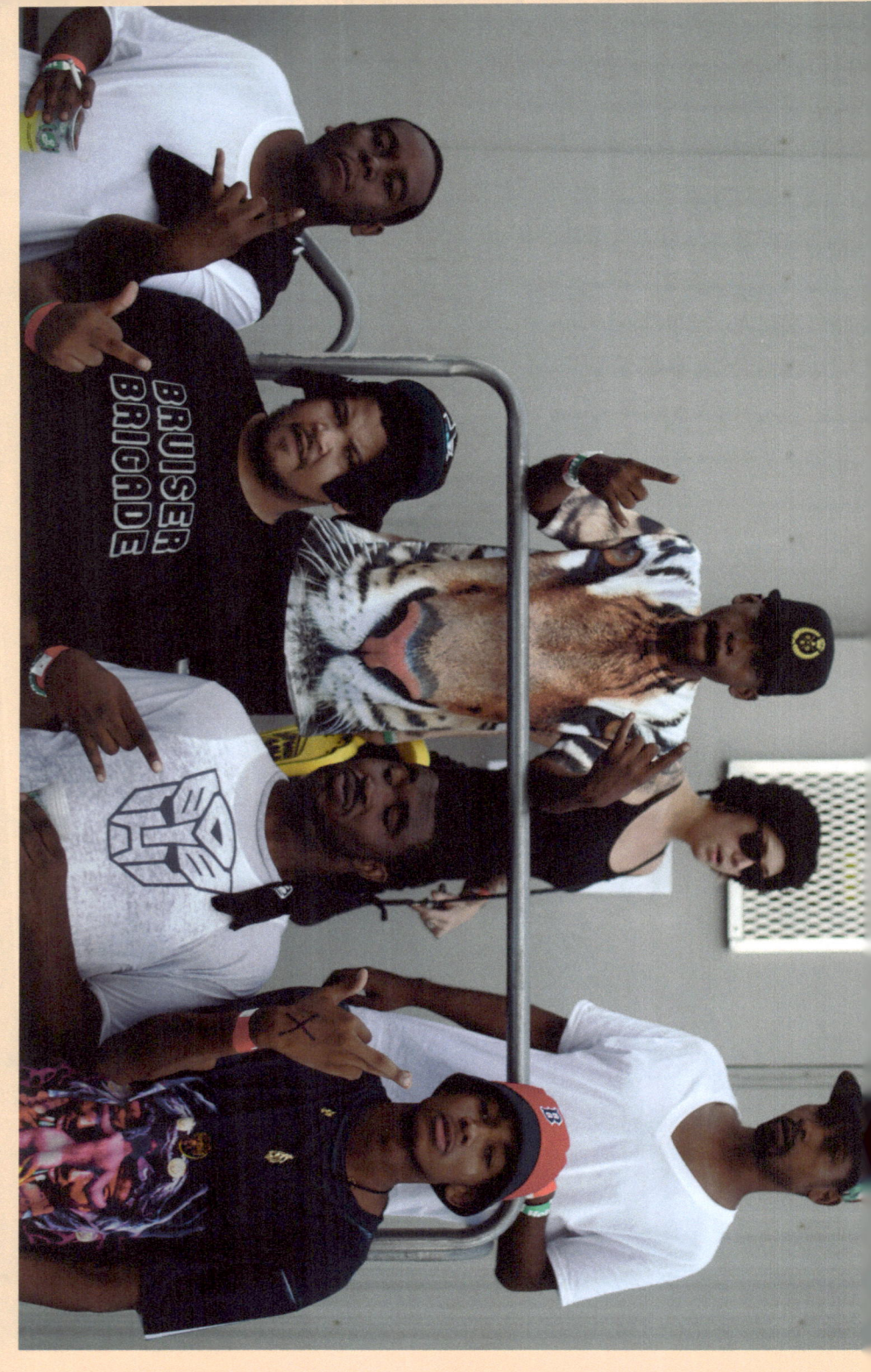

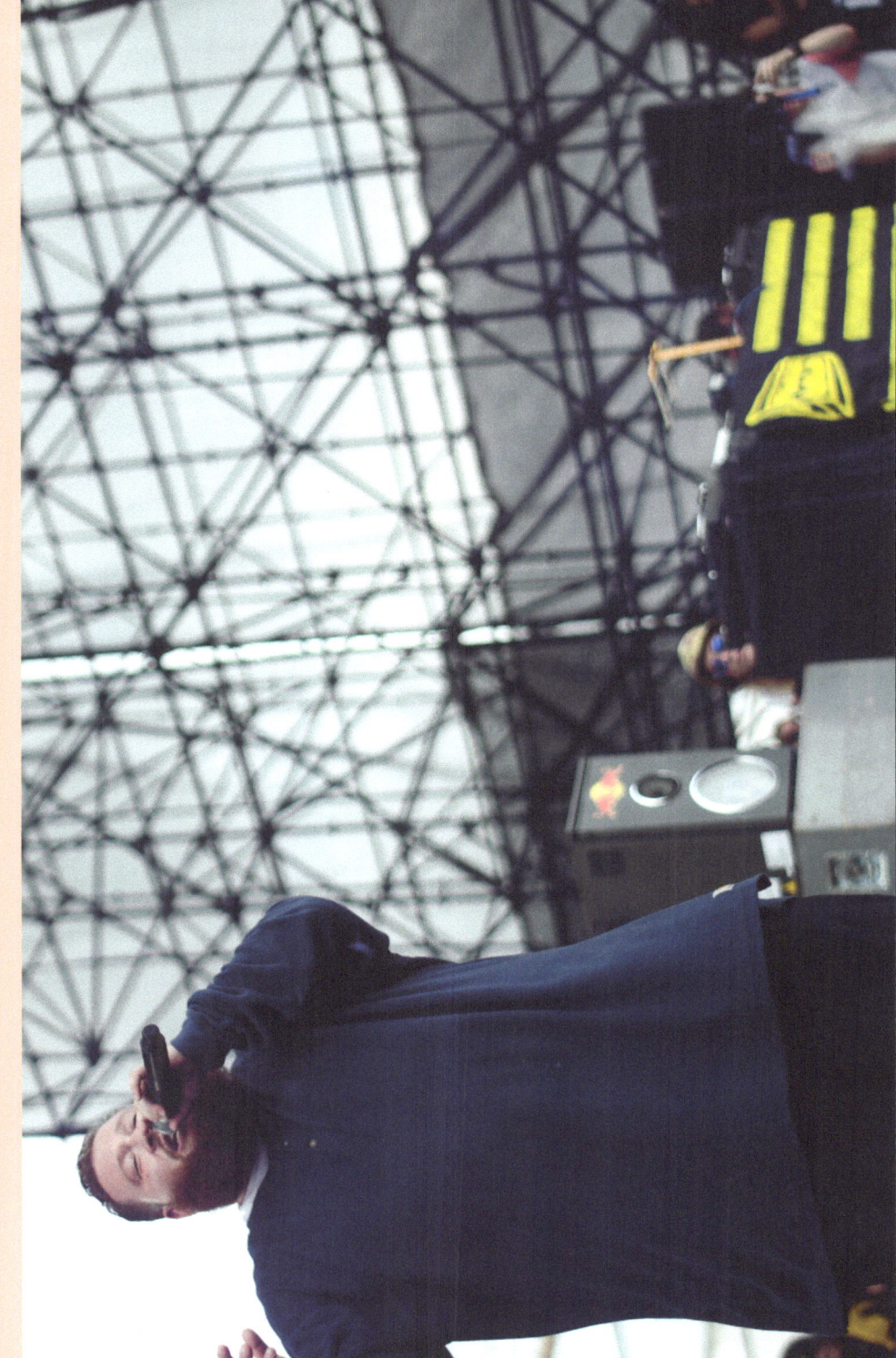

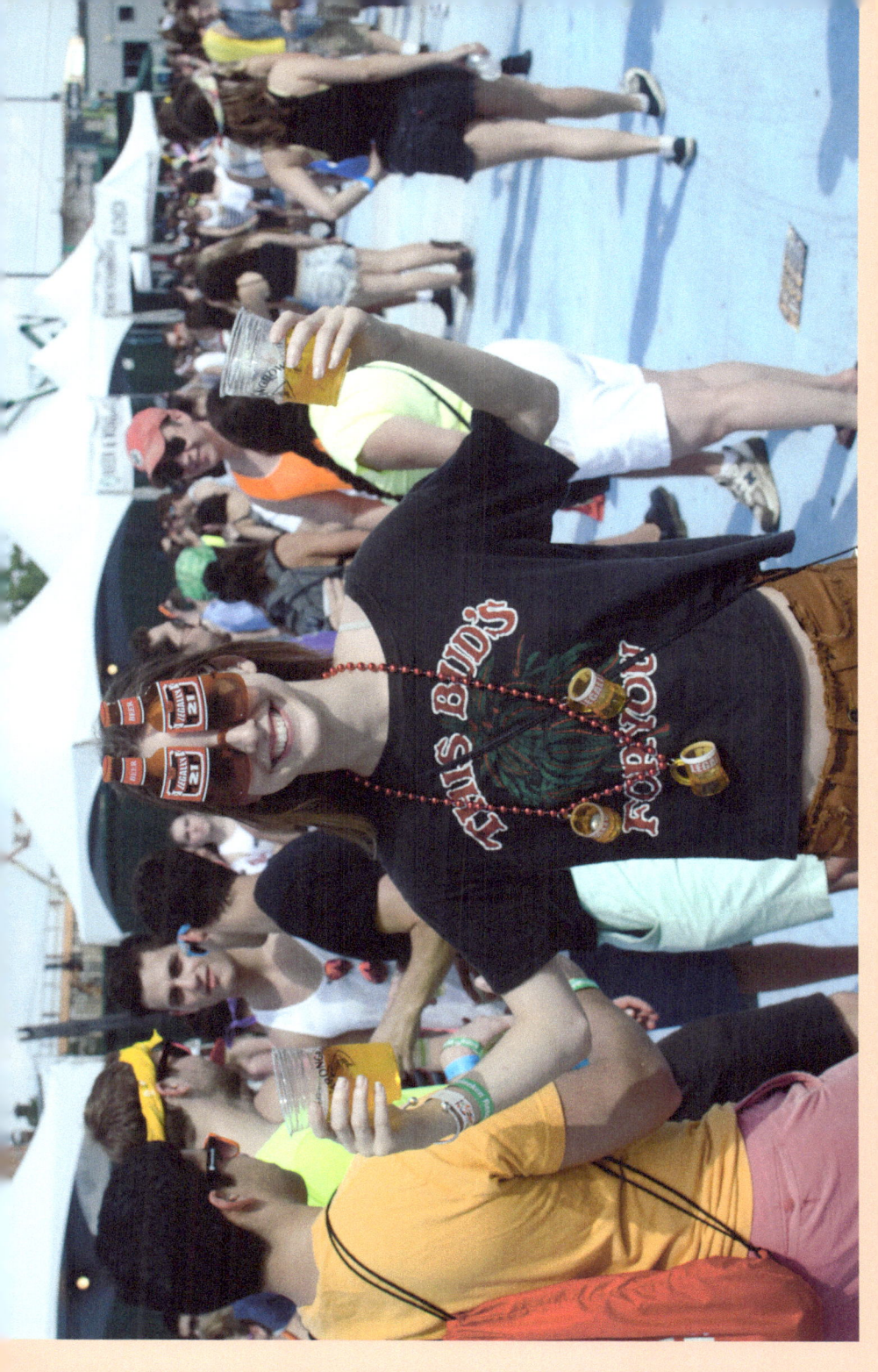

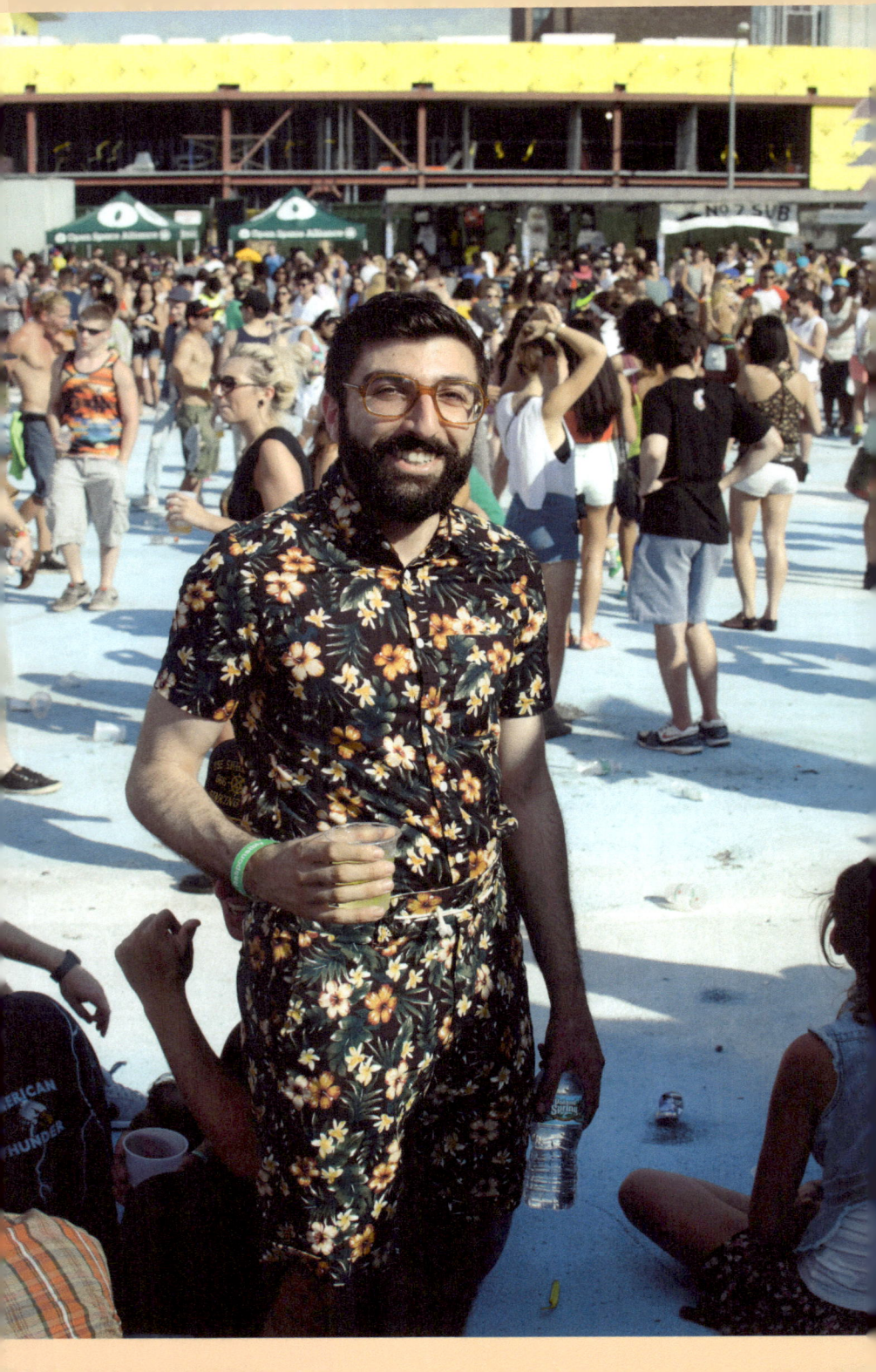

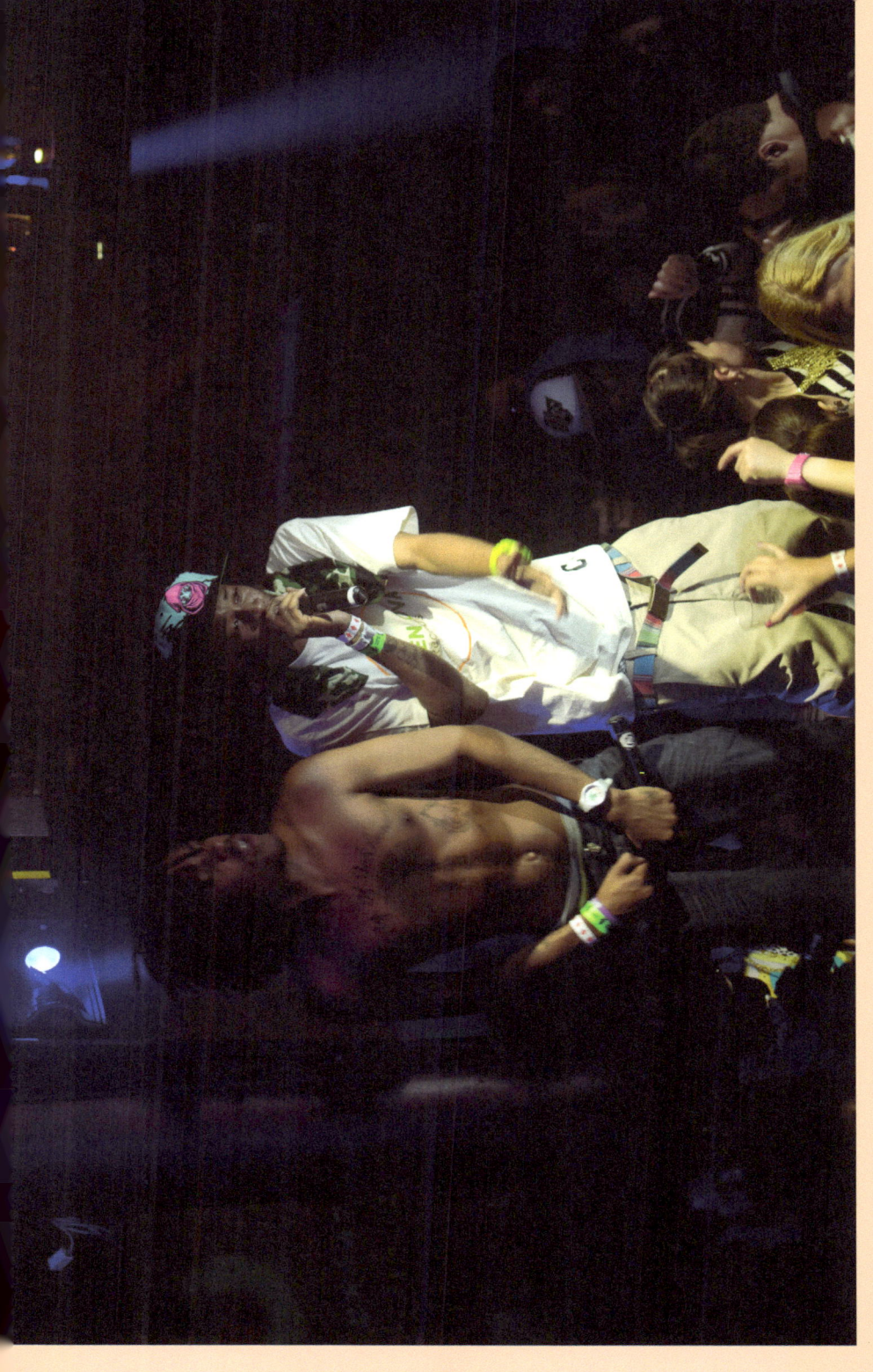

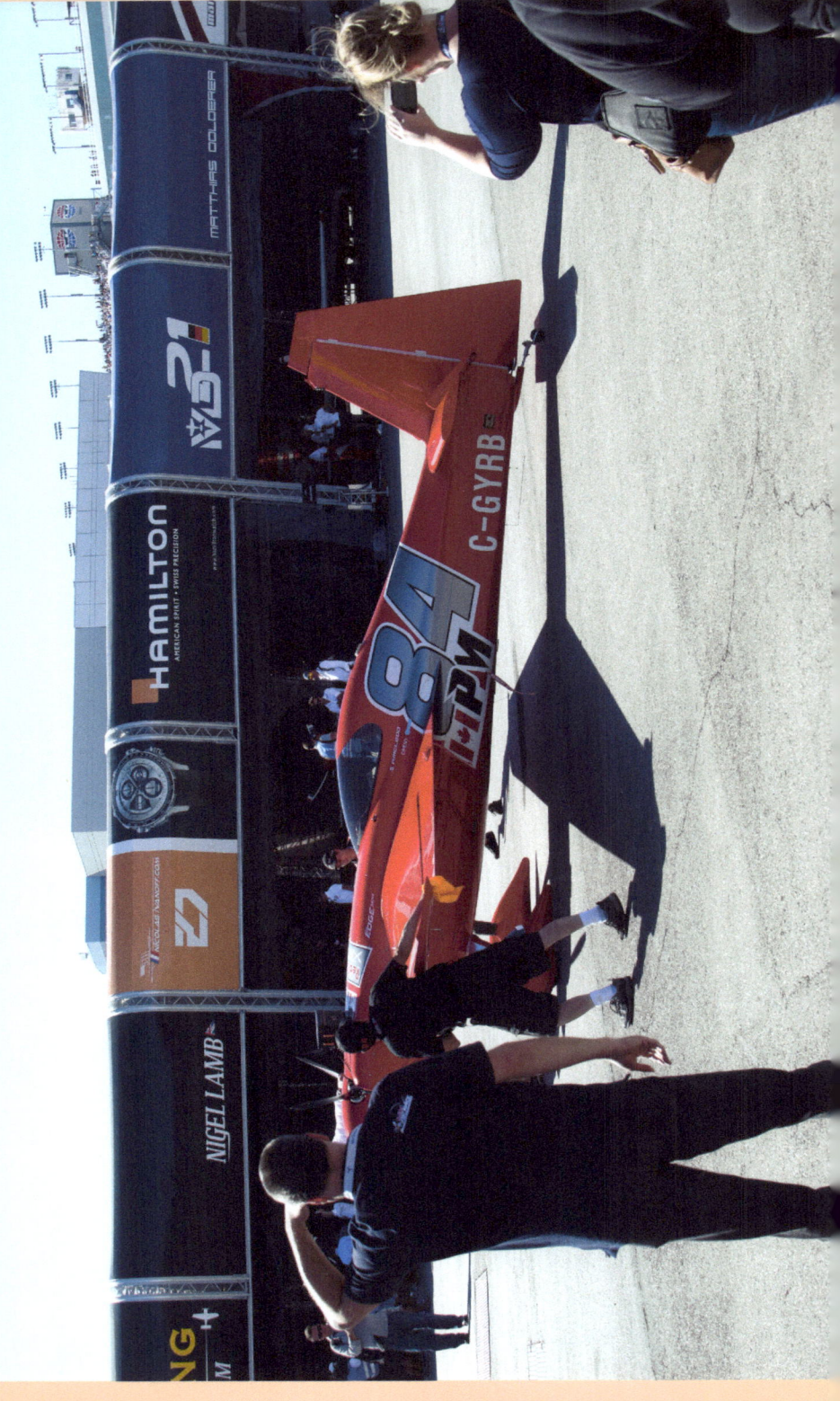

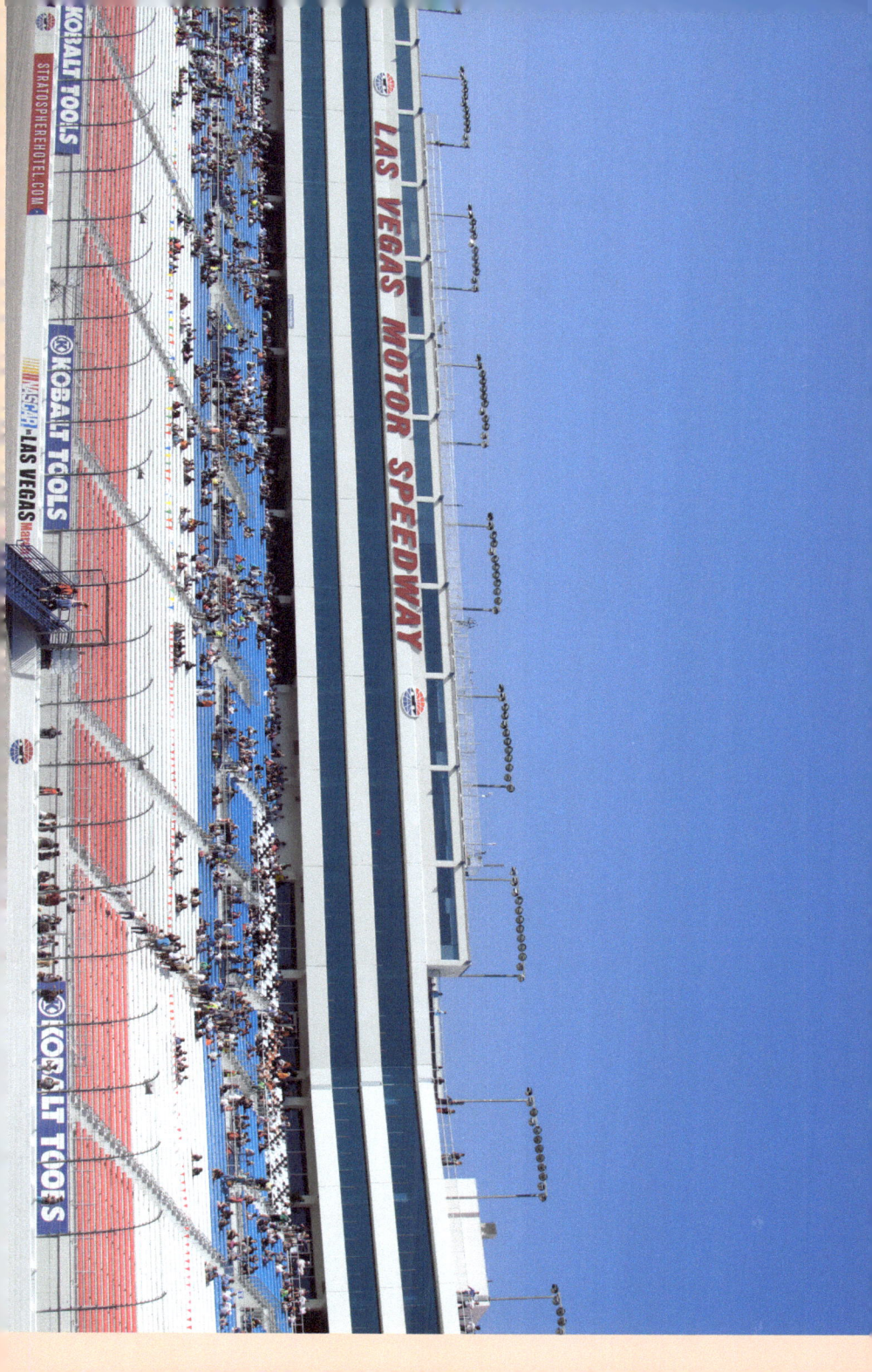

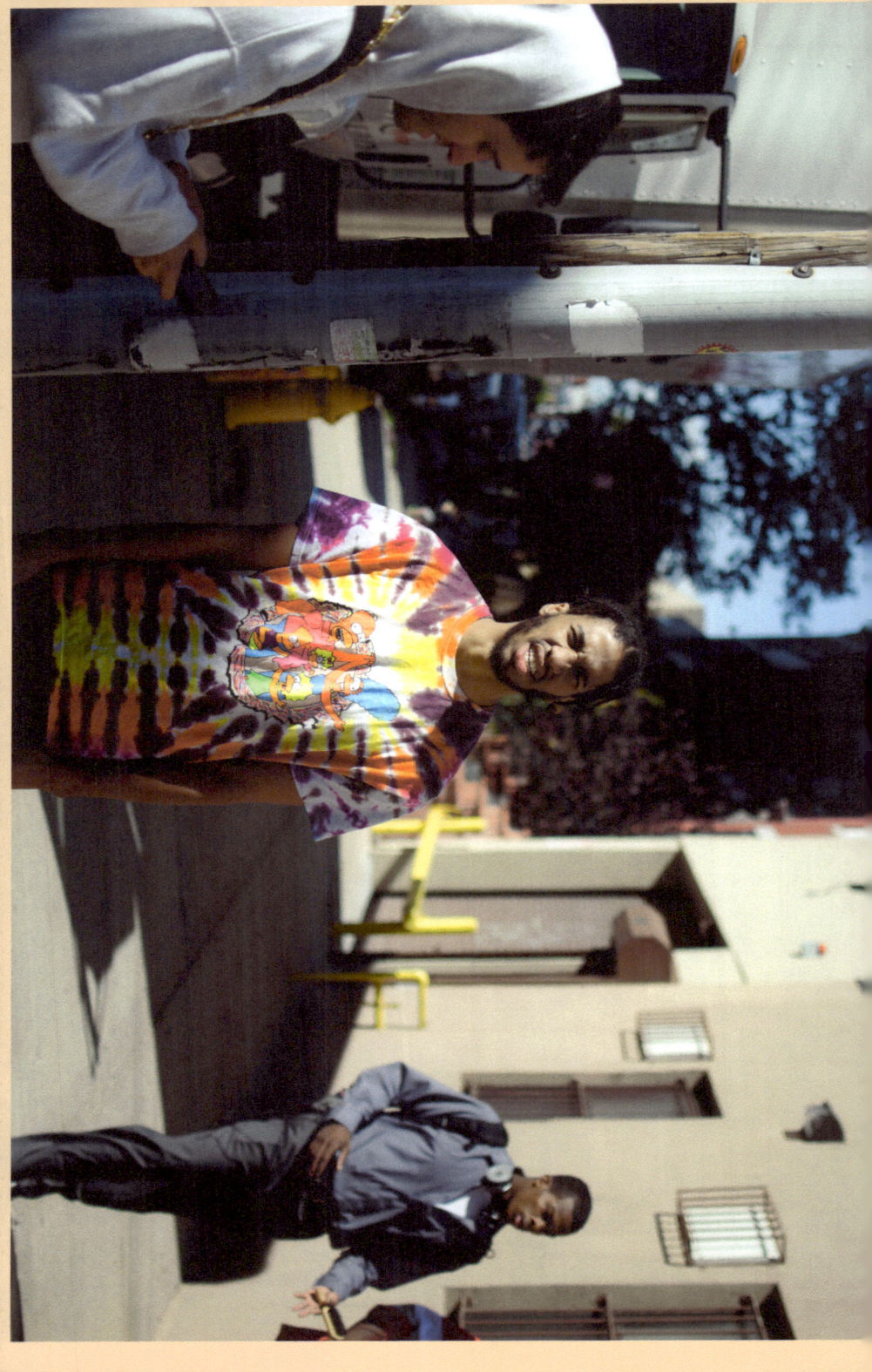

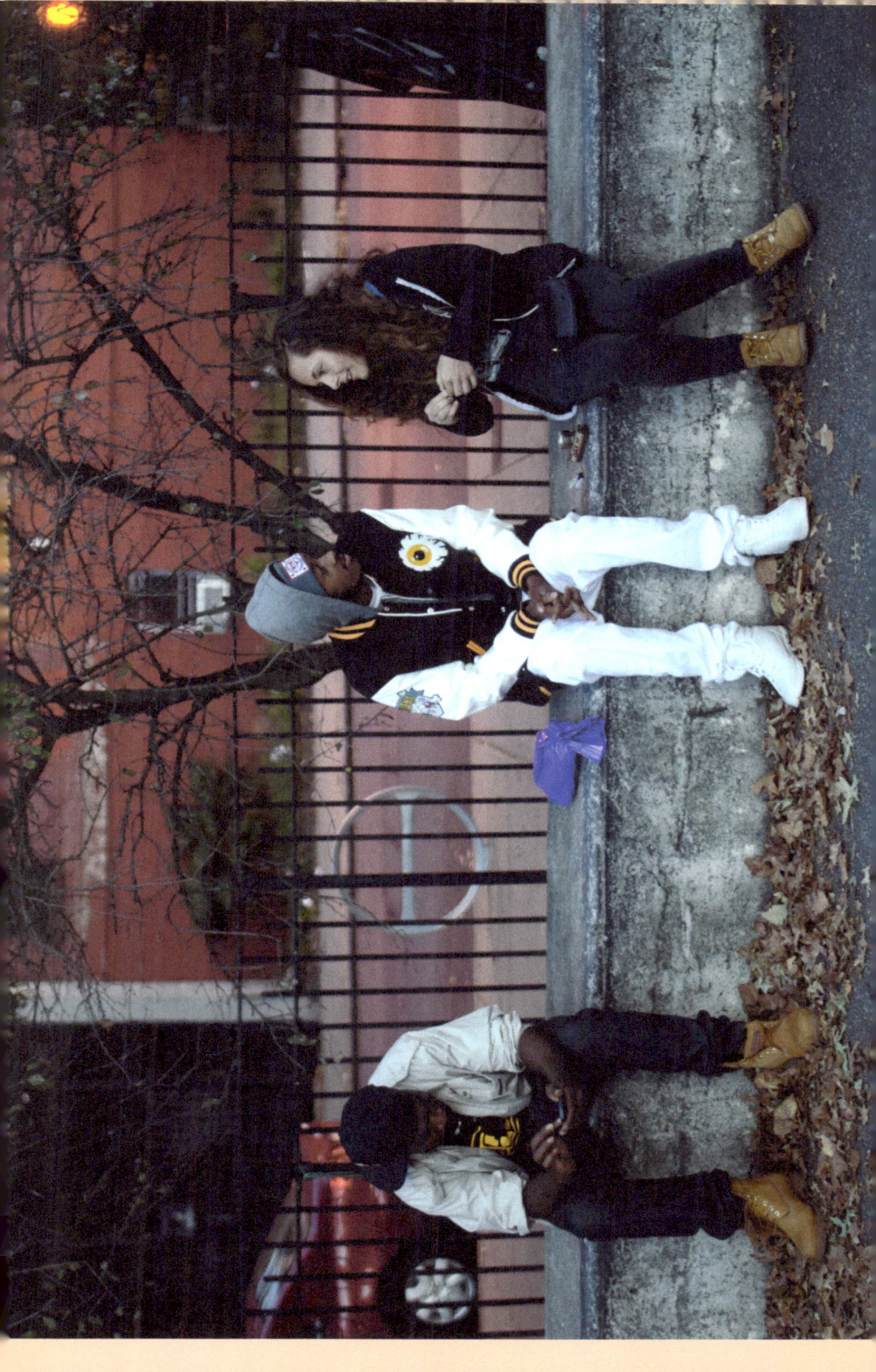

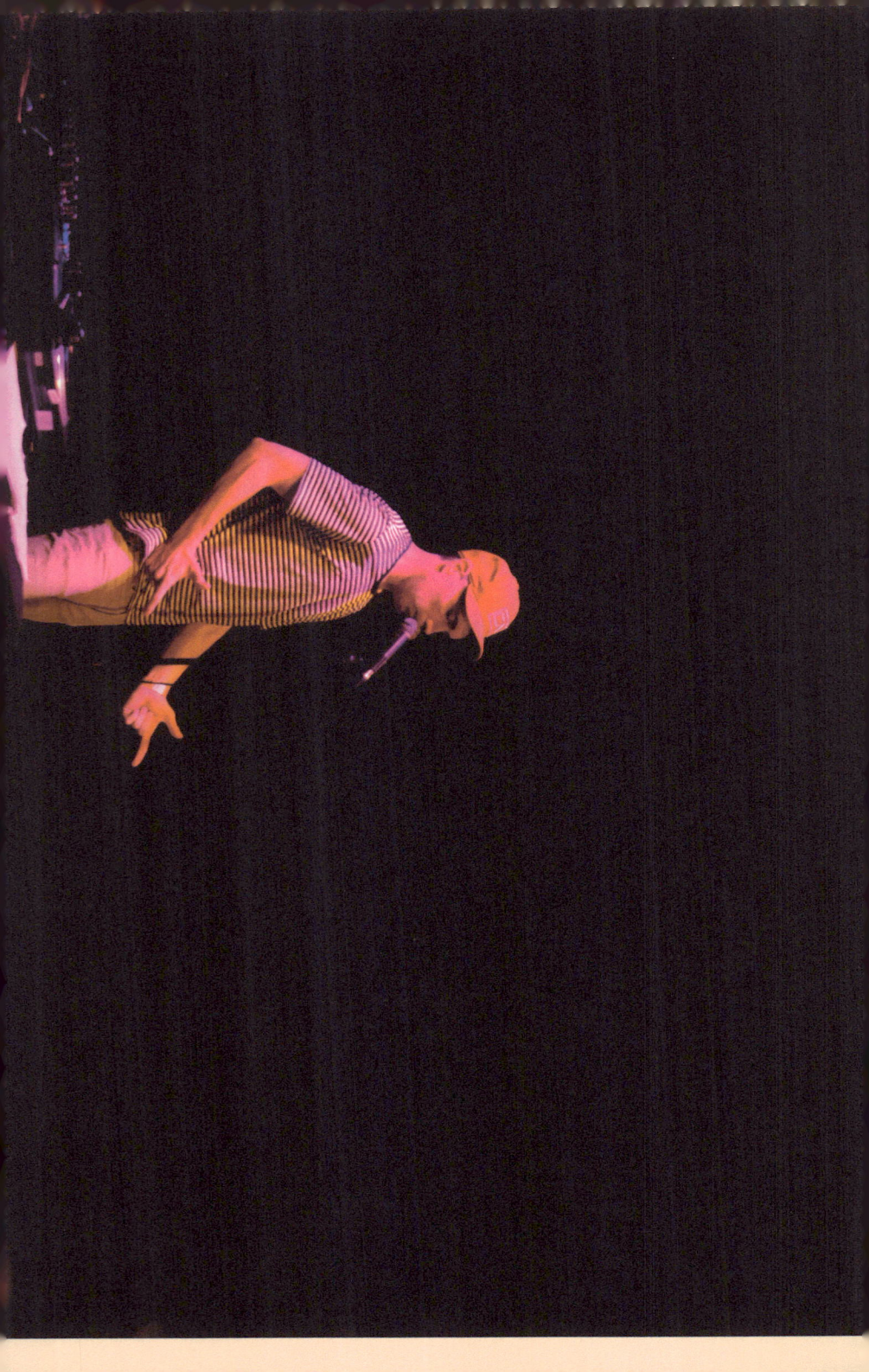

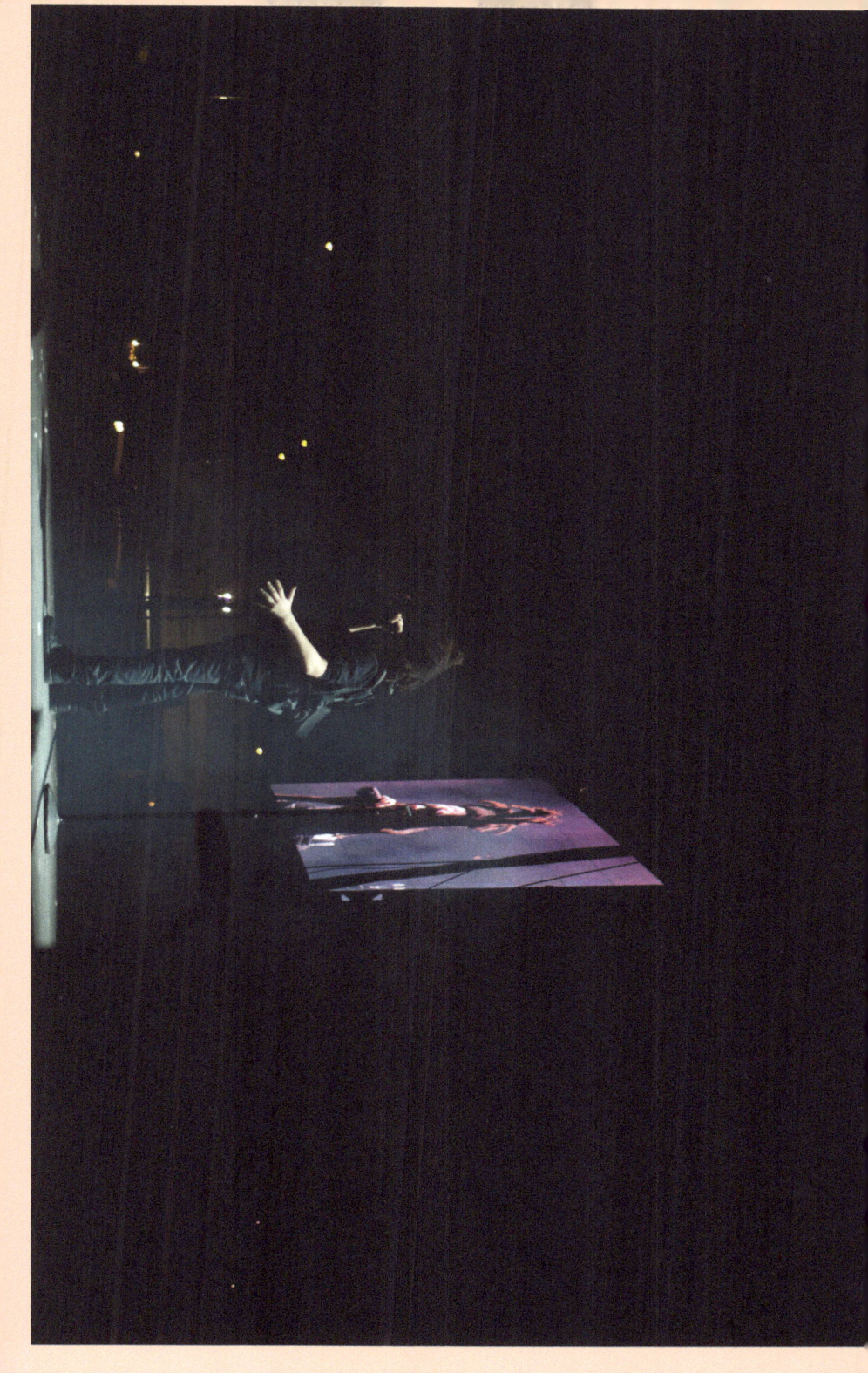

@EASYONTHEEXTRAS, @MRS.ARDELEAN

AFRO PUNK 2013

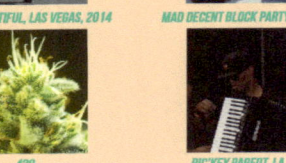
FOOLS GOLD DAY OFF, NYC, 2013

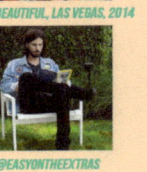
LIFE IS BEAUTIFUL, LAS VEGAS, 2014

AFRIKA BAMBAATAA'S RECORD COLLECTION

LIFE IS BEAUTIFUL, LAS VEGAS, 2014

MAD DECENT BLOCK PARTY, NYC, 2013

@EASYONTHEEXTRAS

420

420

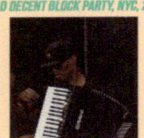
RIC'KEY PAGEOT, LA, 2017

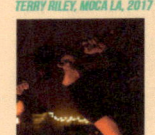
420

420

420

420

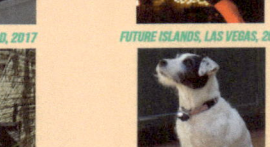
TERRY RILEY, MOCA LA, 2017

OTLA, 2016

@ZACHMOLDOF, @MUNECA_DE_TRAPO, 2016

NORTH HOLLYWOOD, 2017

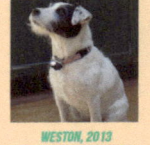
FUTURE ISLANDS, LAS VEGAS, 2014

EVERGLADES, 2015

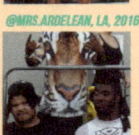
@MRS.ARDELEAN, LA, 2016

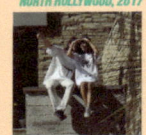
@EASYONTHEEXTRAS, @MRS.ARDELEAN

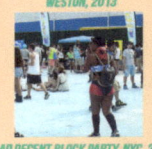
WESTON, 2013

MYKKI BLANCO, NYC, 2013

BRUISER BRIGADE, NYC, 2013

ACTION BRONSON, NYC, 2013

MAD DECENT BLOCK PARTY, NYC, 2013

MAD DECENT BLOCK PARTY, NYC, 2013

MAD DECENT BLOCK PARTY, NYC, 2013

MAIN ATTRAKIONZ, SF, 2012

RED BULL AIR RACE, LAS VEGAS, 2014

RED BULL AIR RACE, LAS VEGAS, 2014

GOOD GAMES, LAS VEGAS, 2014

LAS VEGAS, 2014

LOFTY 305, NYC, 2013

TRIPLE BLACK, SQUADDA B, NYC, 2013

BUCK 65, LA, 2016

THE WEEKND, LAS VEGAS, 2014

www.ingramcontent.com/pod-product-compliance
Lightning Source LLC
Chambersburg PA
CBHW041209180526
45172CB00006B/1219